Inspiring Grayscales

35 Images to Inspire Creativity and Relaxation

Volume One

Brian VanDeWiel

Copyright © 2016 Brian VanDeWiel

View the author's website at:

www.grayscalecoloringbook.com

All rights reserved, including the right to reproduce this
book or portions thereof in any form whatsoever.

First Edition

ISBN: 1535407611
ISBN-13: 978-1535407618

Author's Greeting:

Thank you for purchasing the first volume of Inspiring Grayscales – 35 Images to Inspire Creativity and Relaxation. Inside you will find highly detailed images for you to bring to life. Grayscale offers a unique advantage to your coloring enjoyment by presenting shadows to give a flat image perspective and dimension. You can color these pages in the same way you might color a page with only outlines. Over lighter parts of the page, shade lightly with your utensil. Over darker areas, you may color in with your darker shades. Colored pencils work best with grayscale images as they allow the background to show better than markers or thicker materials.

The images were specially chosen to offer the most expression from the artist coloring the page. Scenes range from a Chinese beach to a national park in Ukraine. There are 35 images from around the world and surely more than one will peak your creativity.

The natural settings of the image will inspire relaxation. Imagine yourself inside the world and bring it to life with your colors. Meditate as you fill in the colors of the beach or the forest floor. Look over a cliff to join in on the world of cathedrals and enchanting windmills. Enjoy yourself and bring these images to life!

As you finish each image, take pictures and submit them to my website for others to marvel over. Show off your latest shading techniques or unique color palette. If you need your own inspiration, be sure to check out the gallery to see how others imagined the scene.

www.grayscalecoloringbook.com

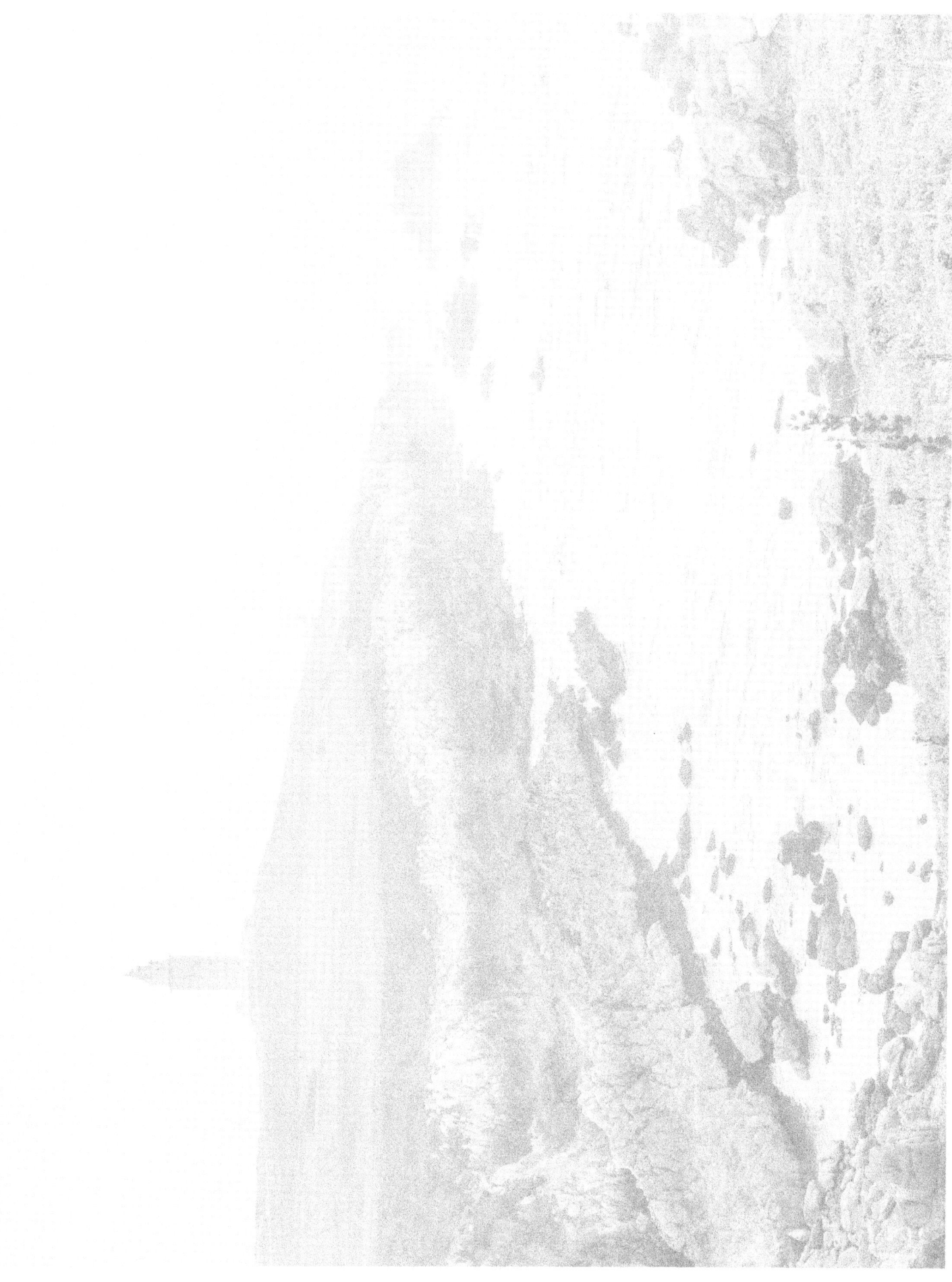

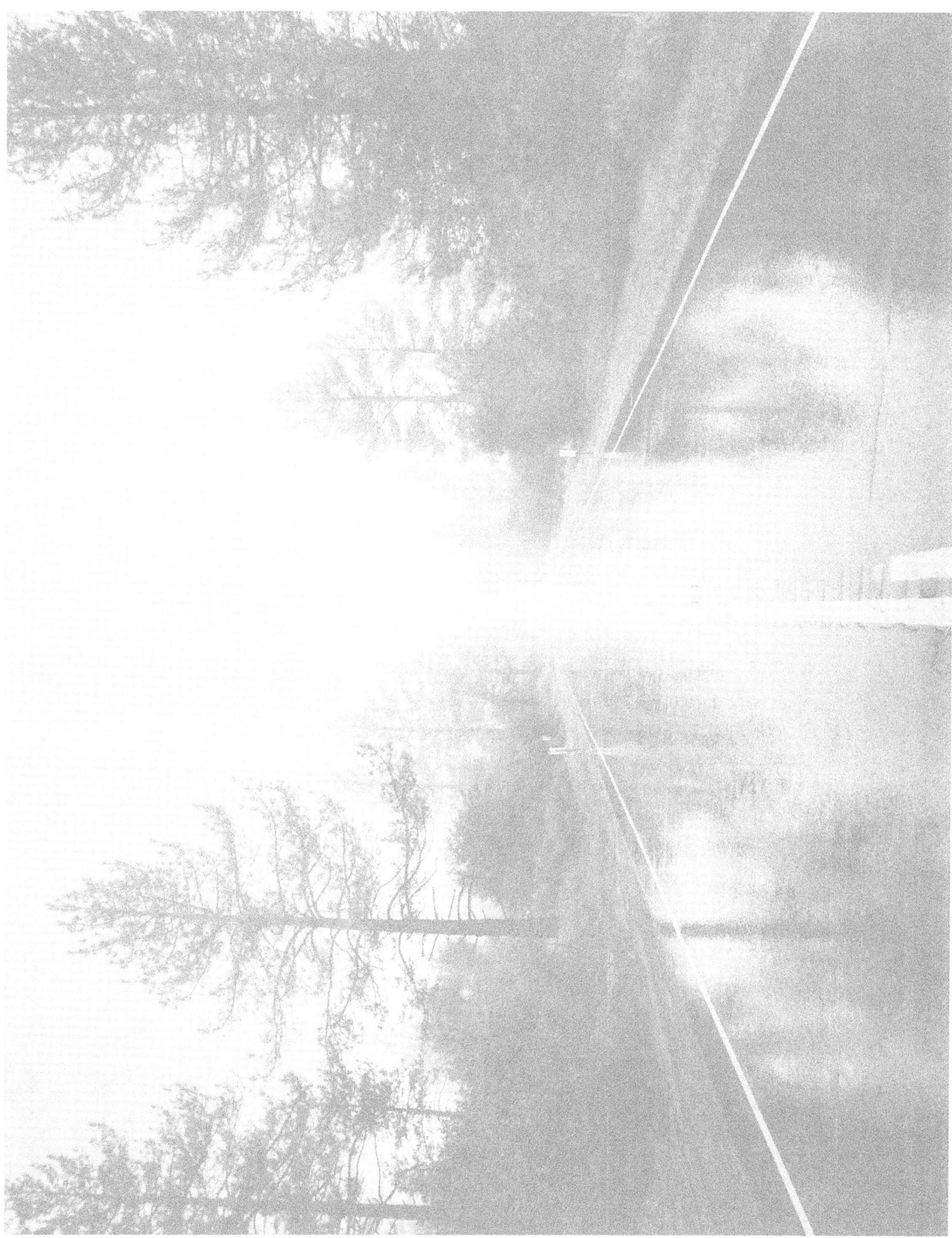

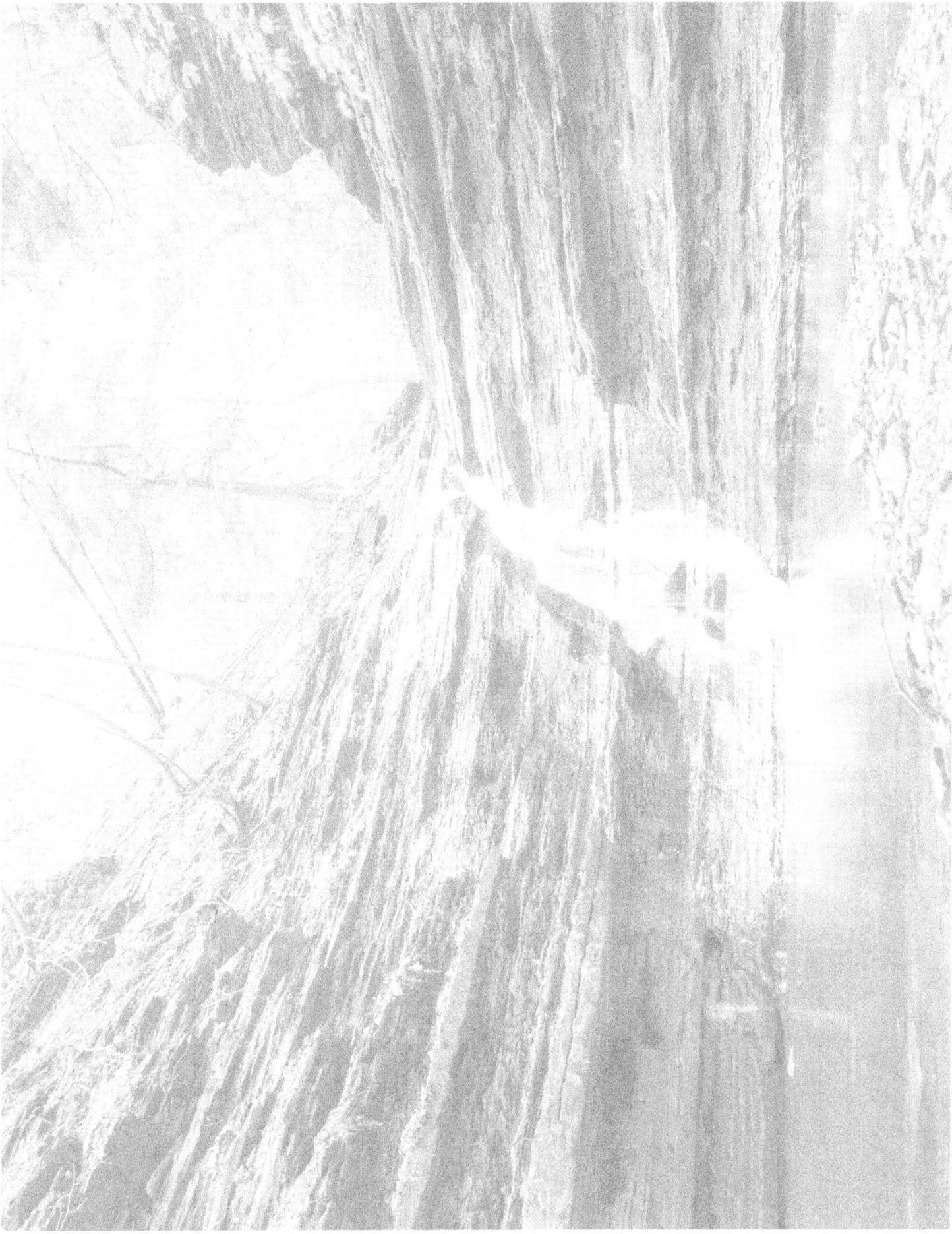

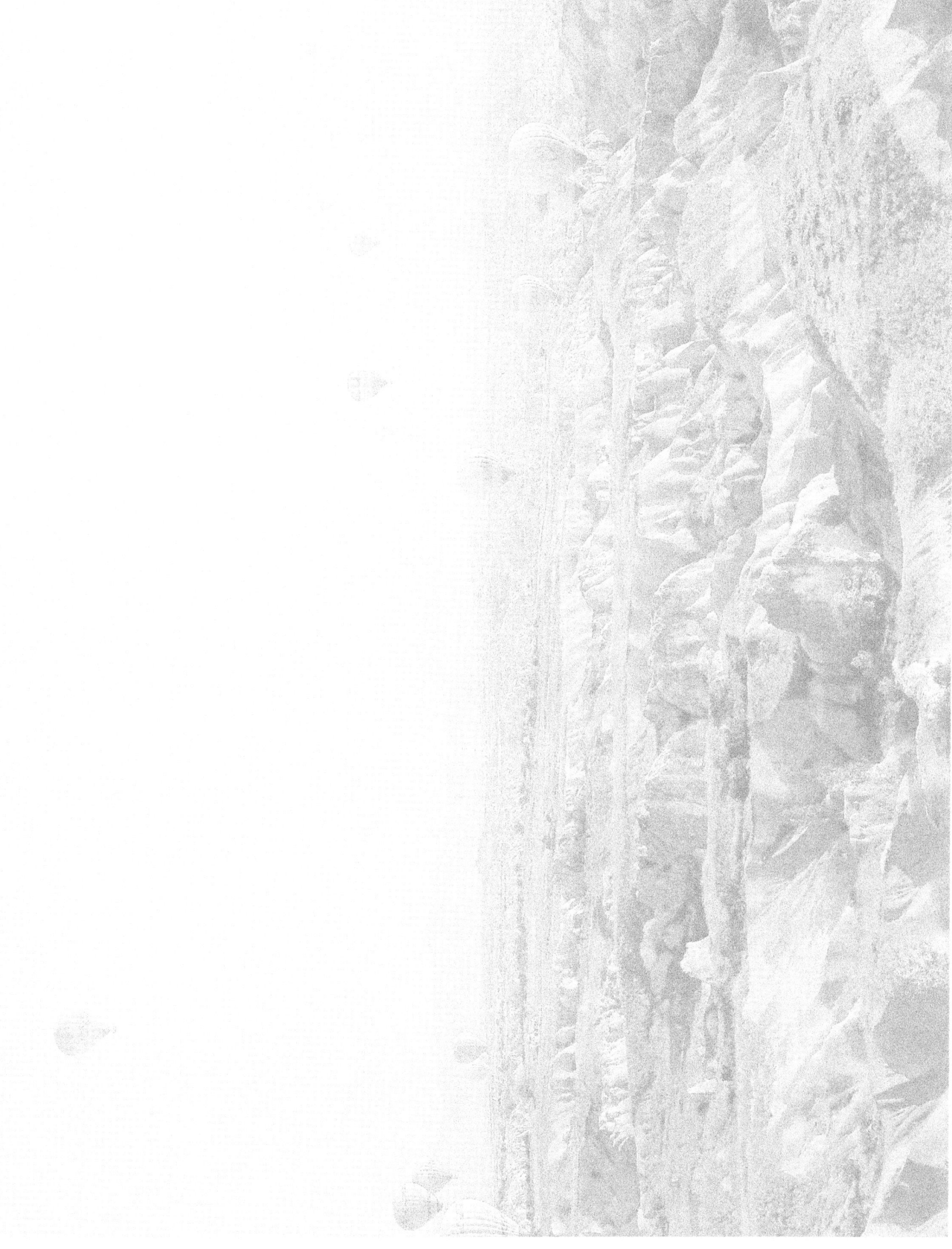

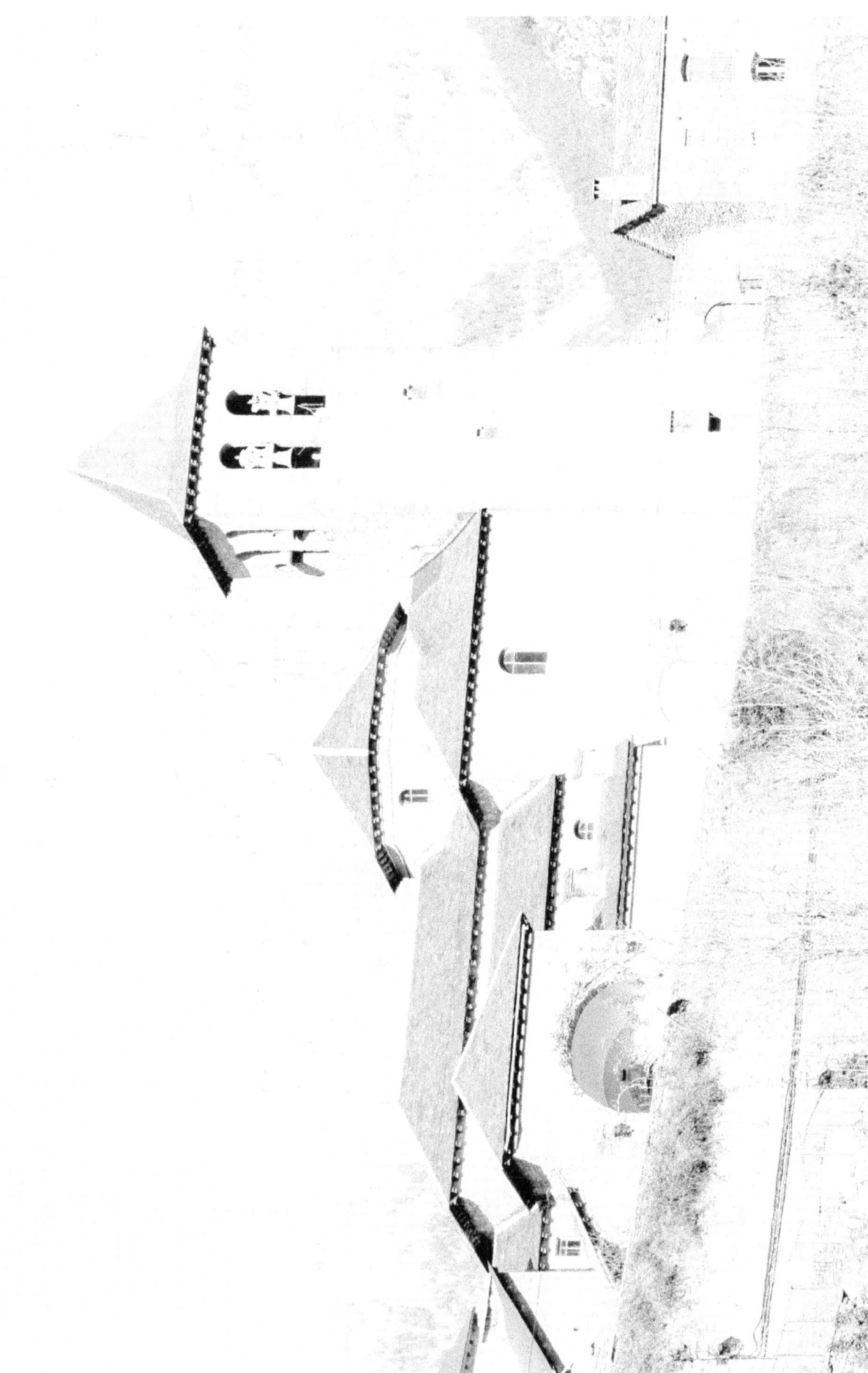

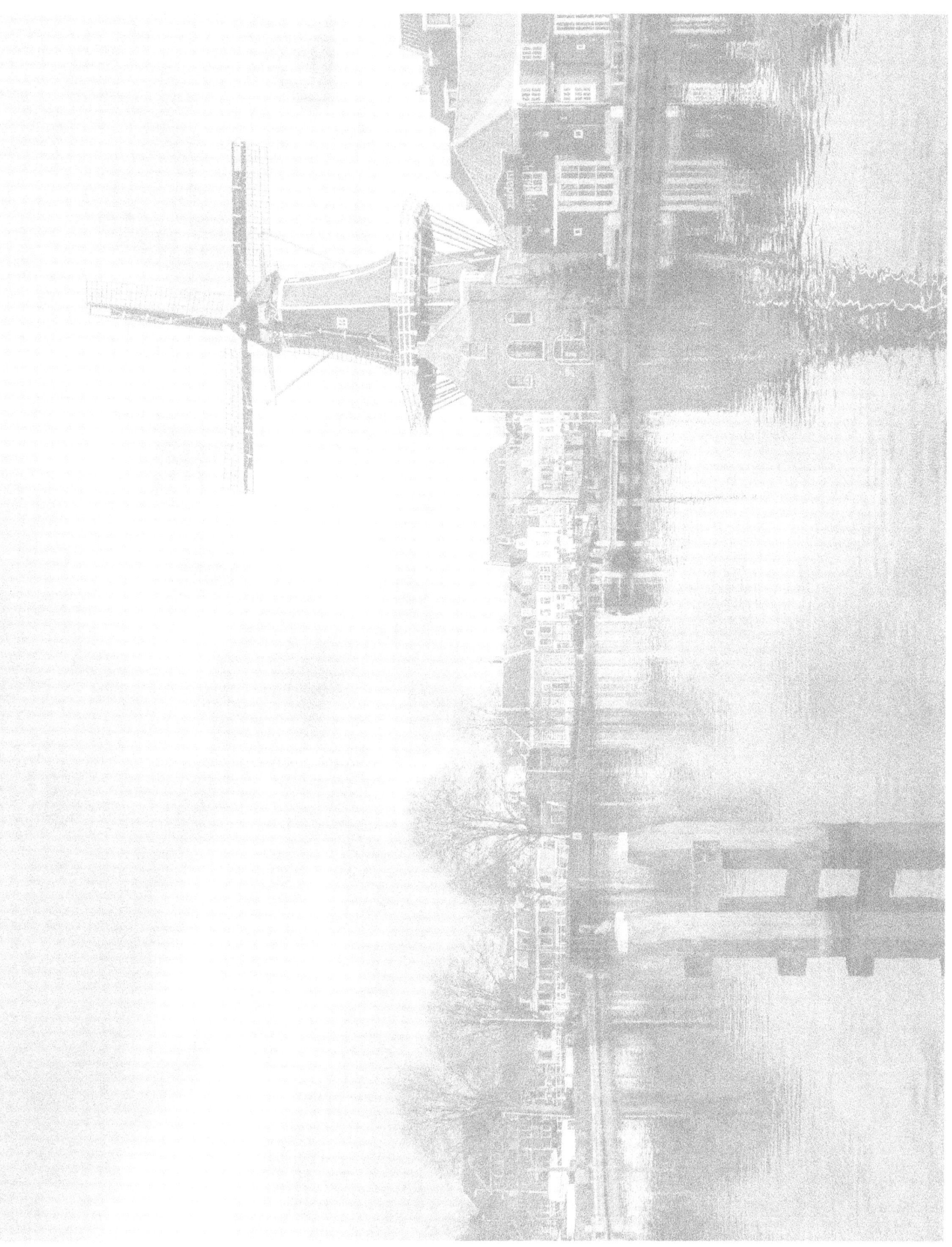

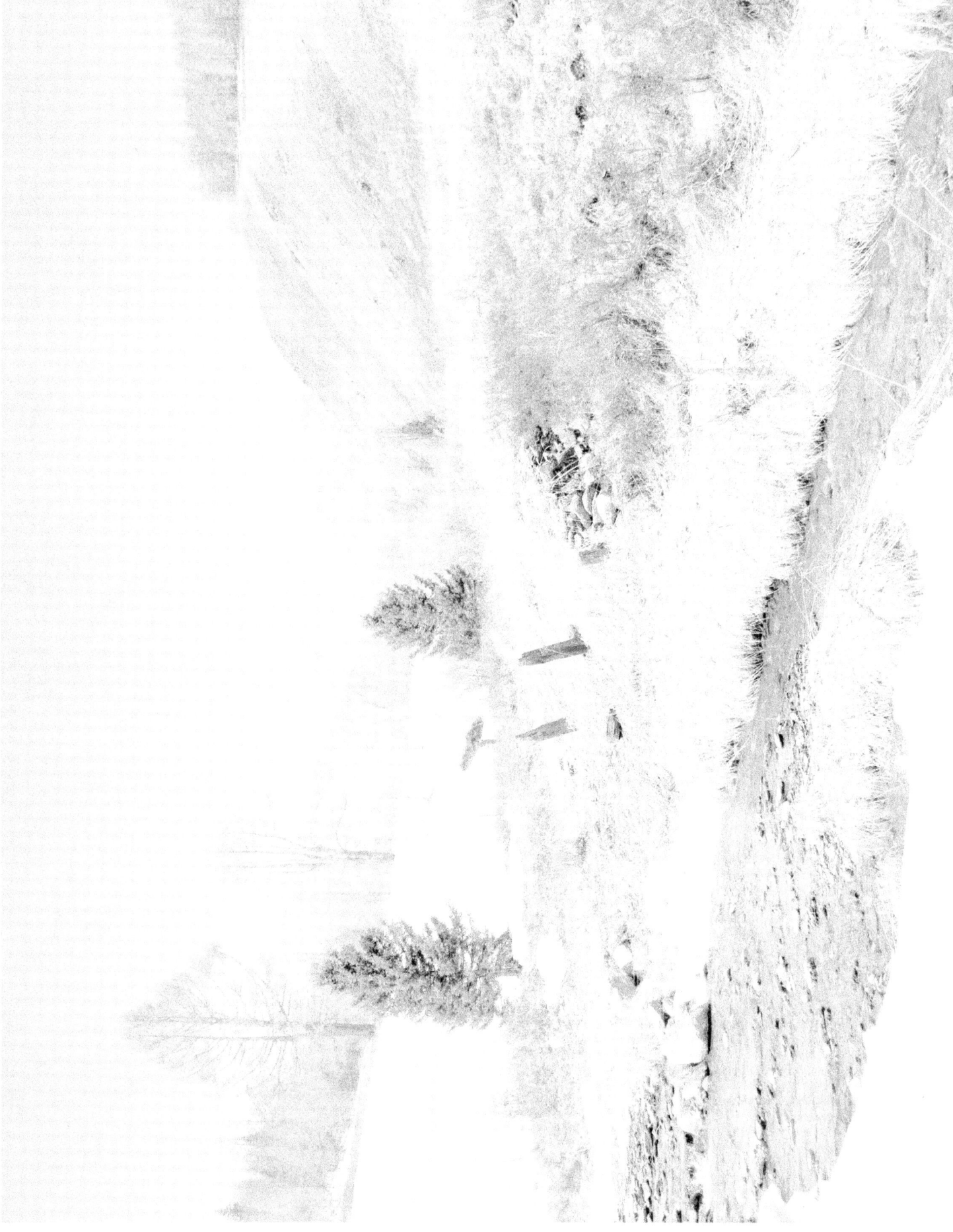

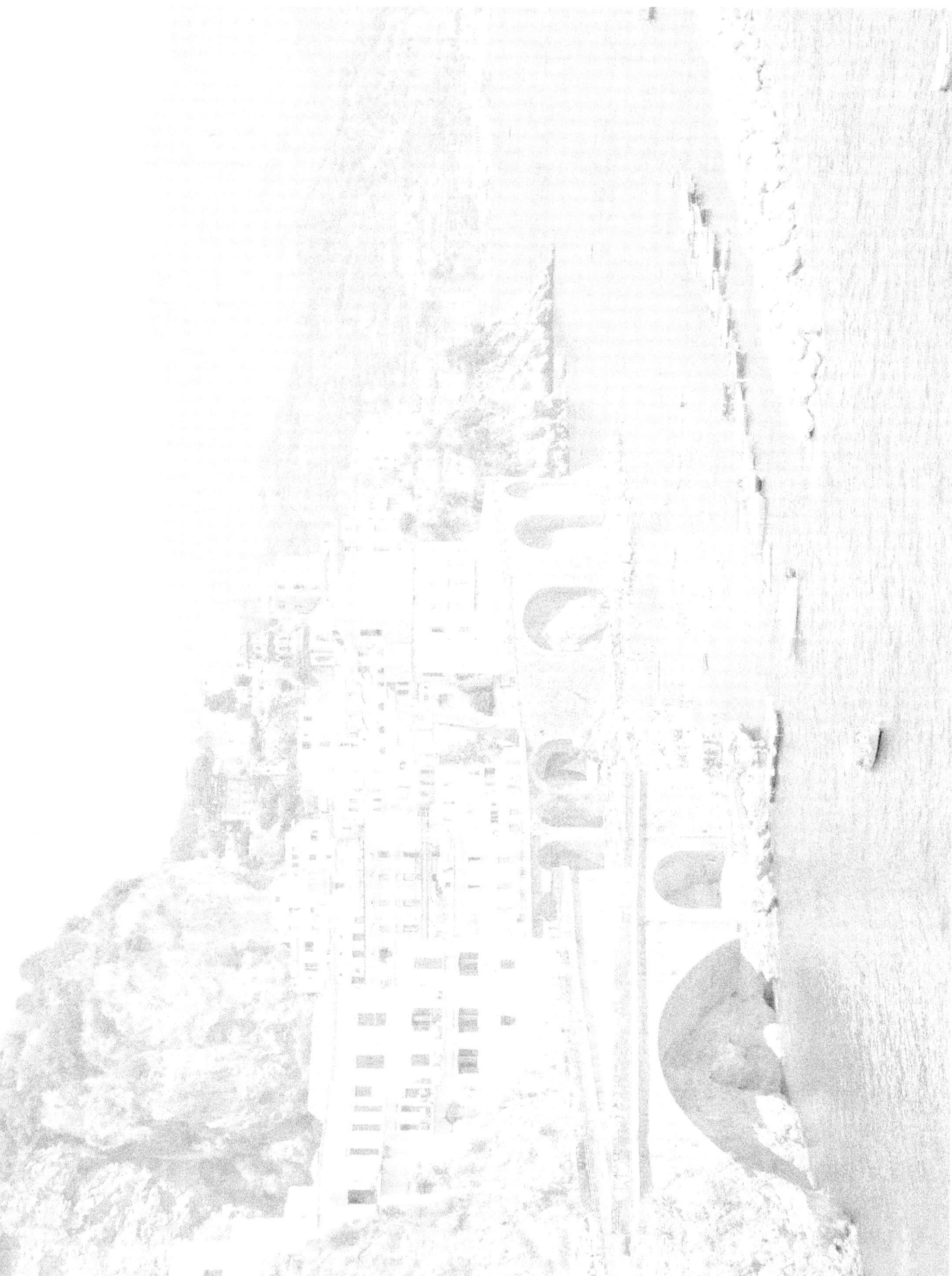

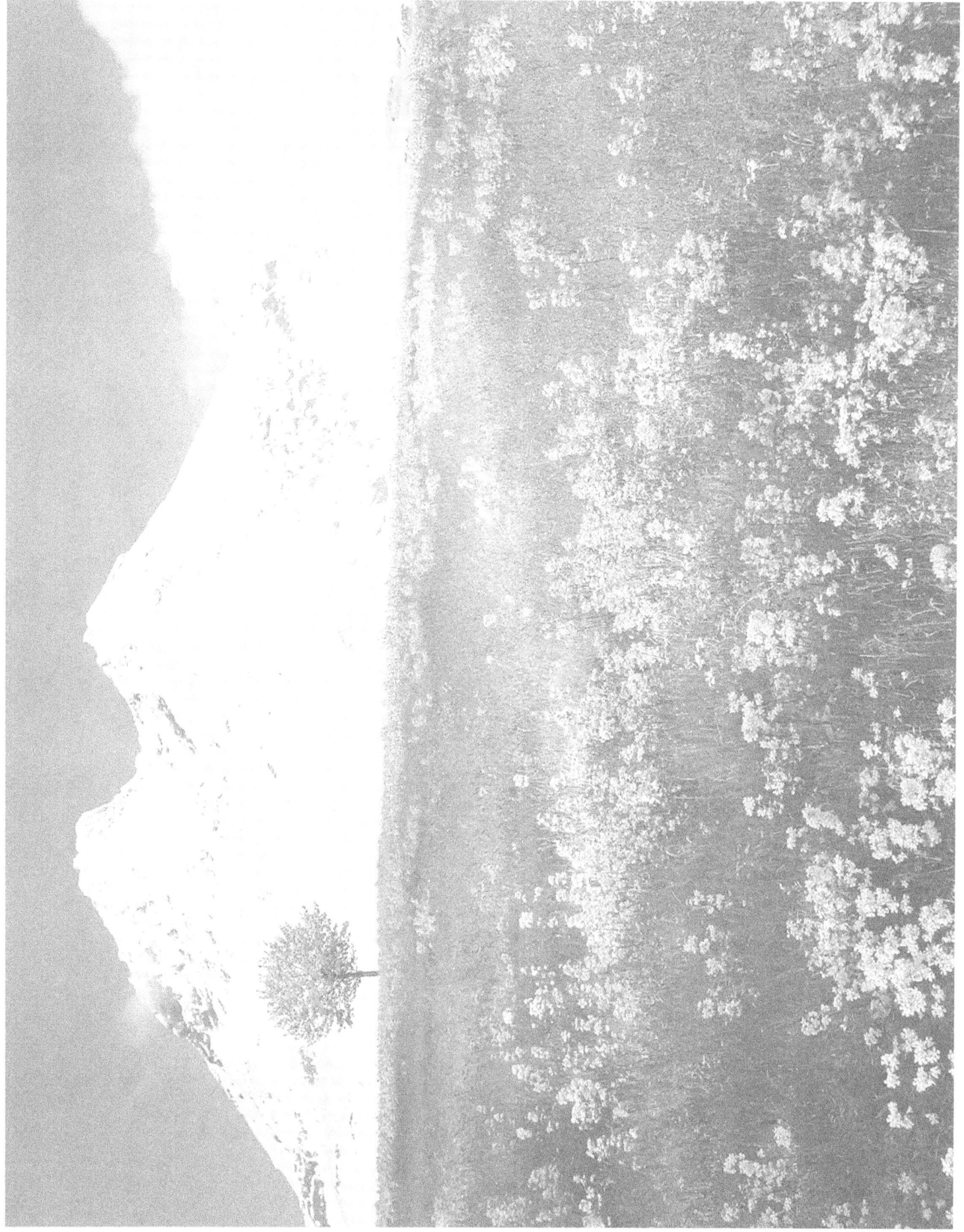

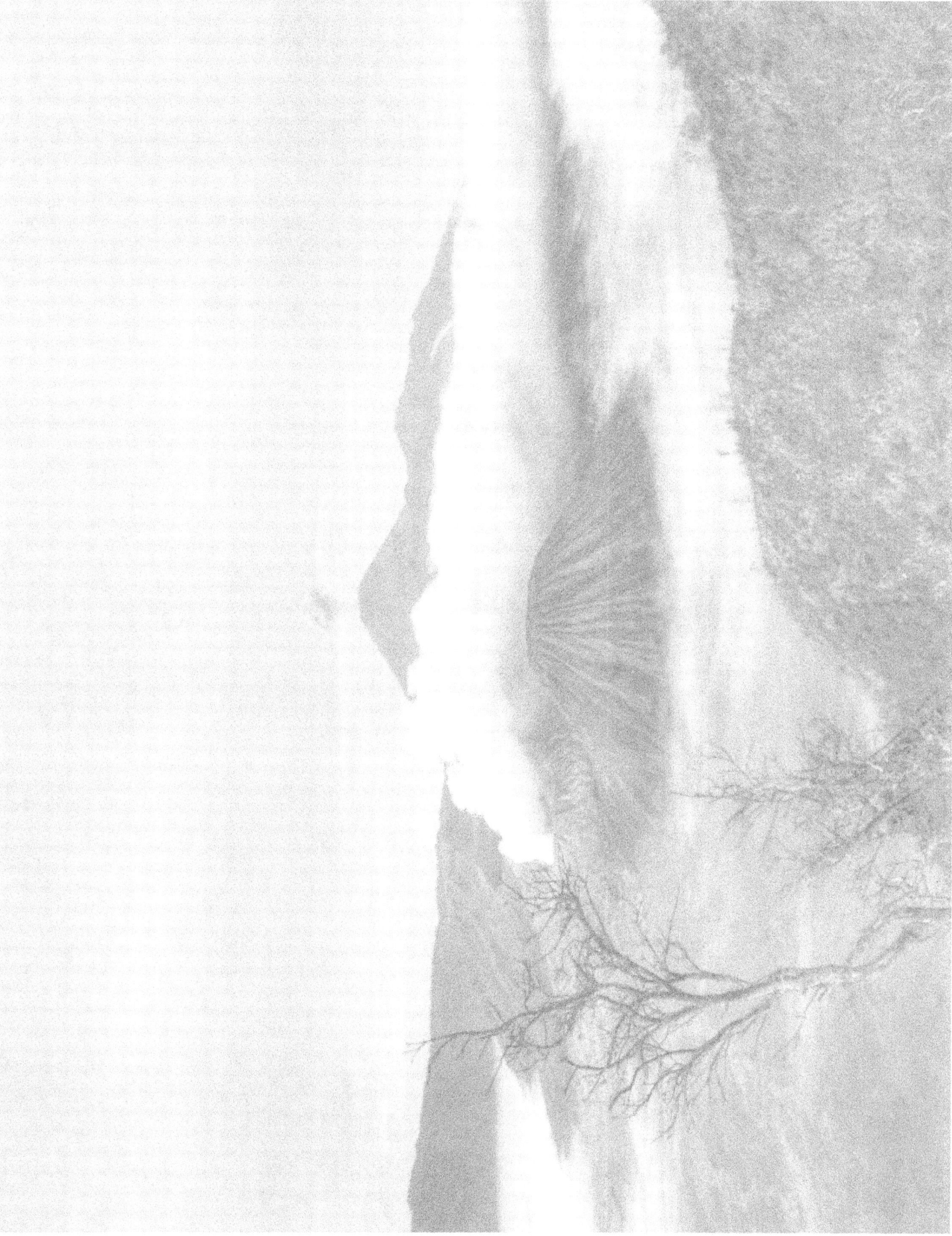

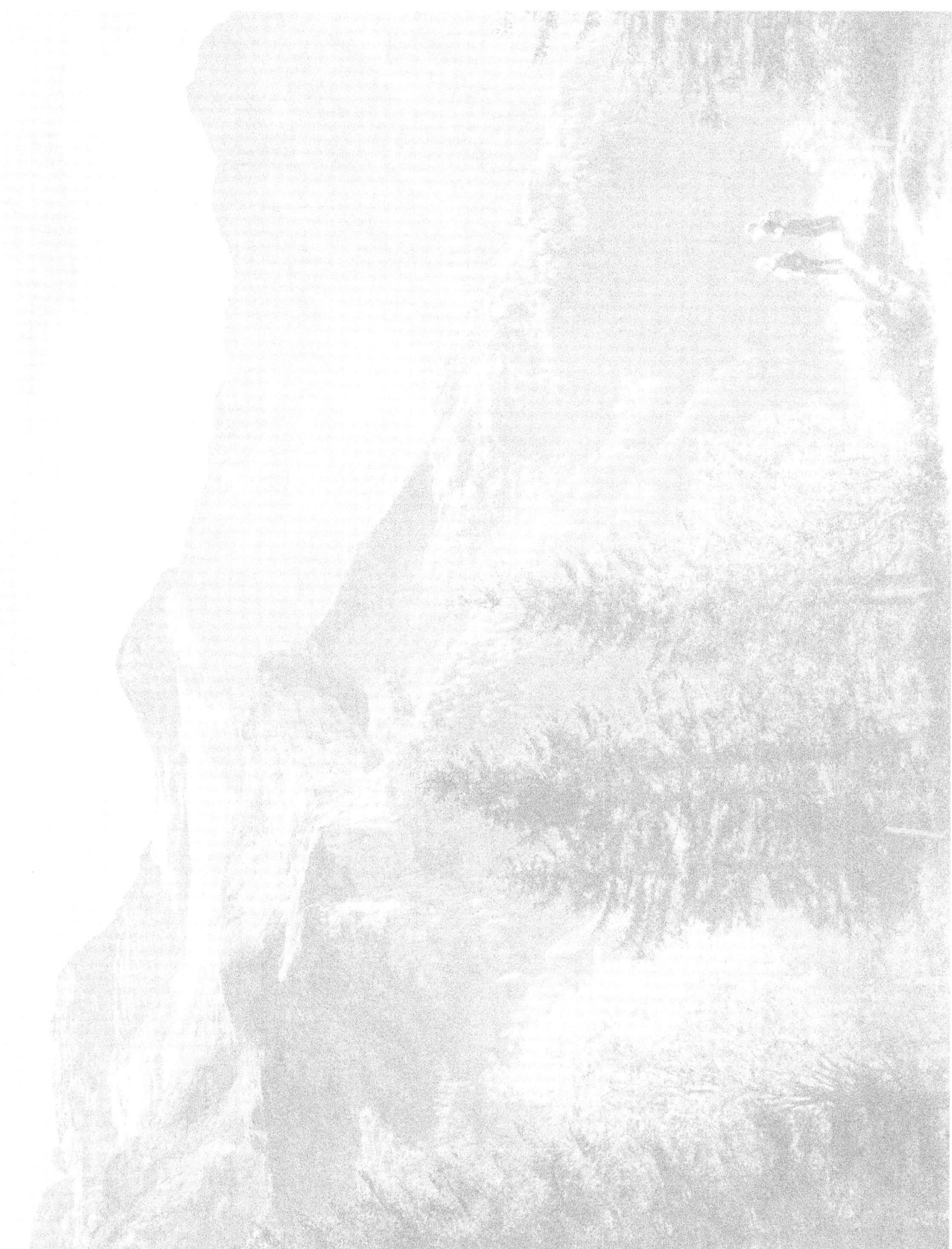

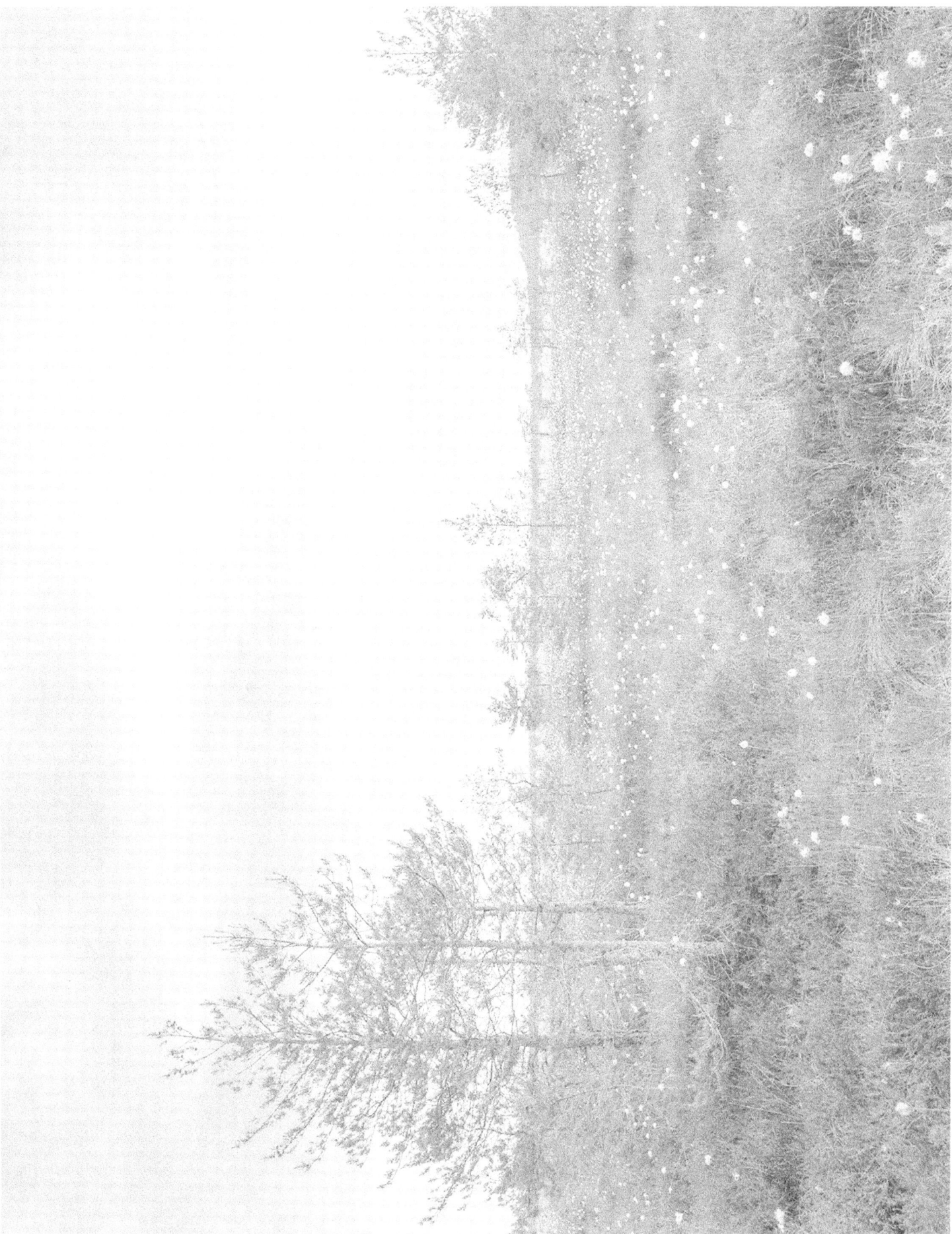

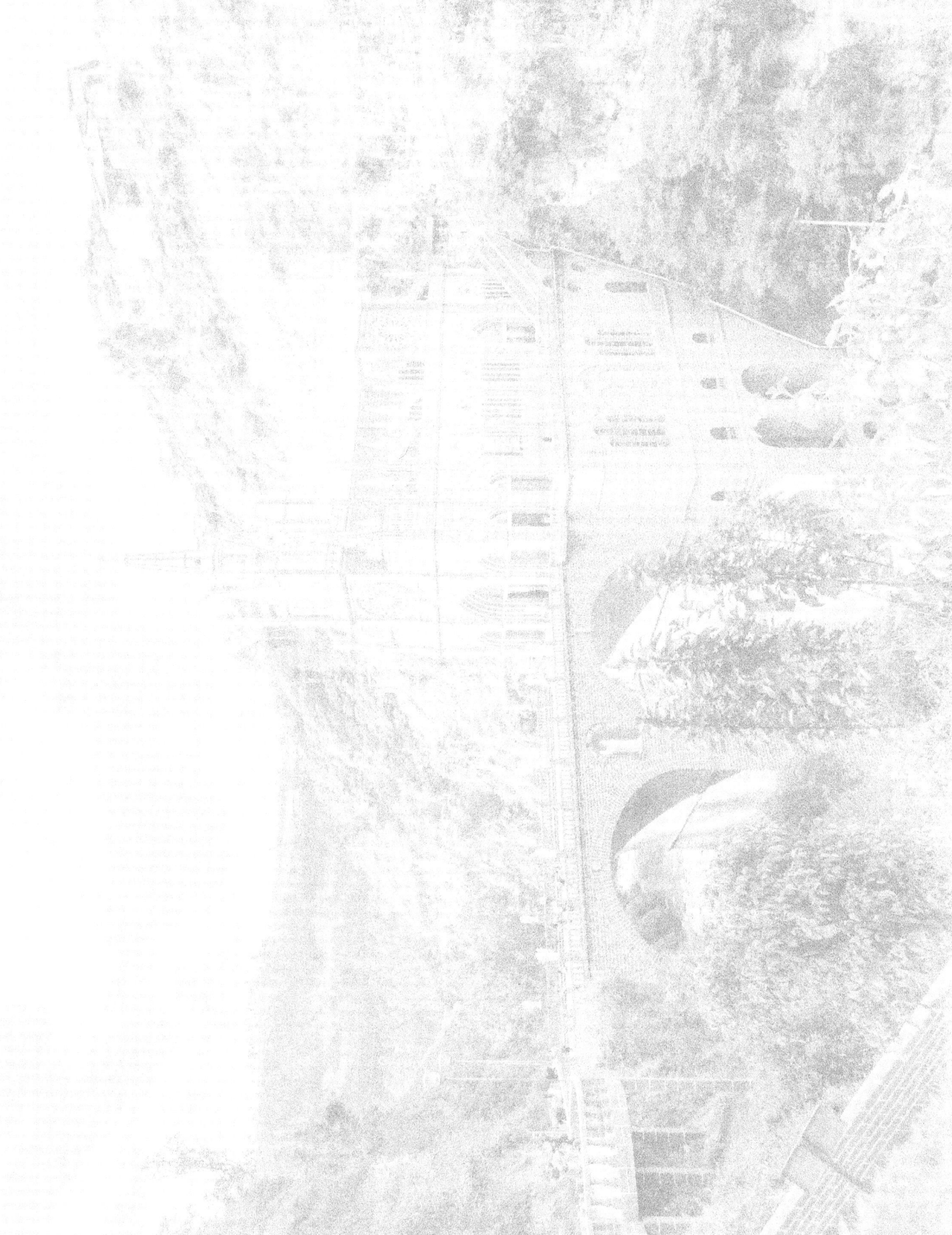

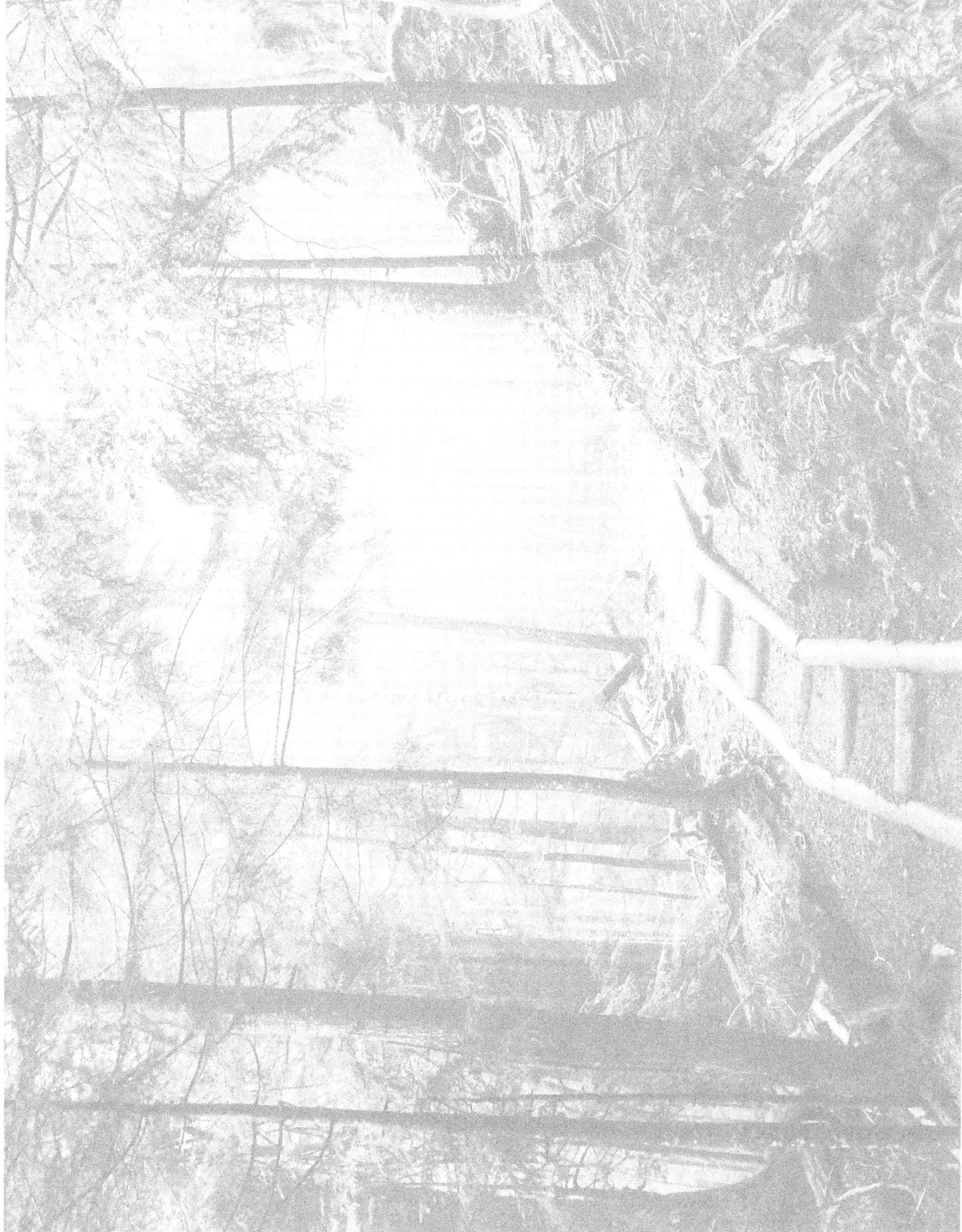

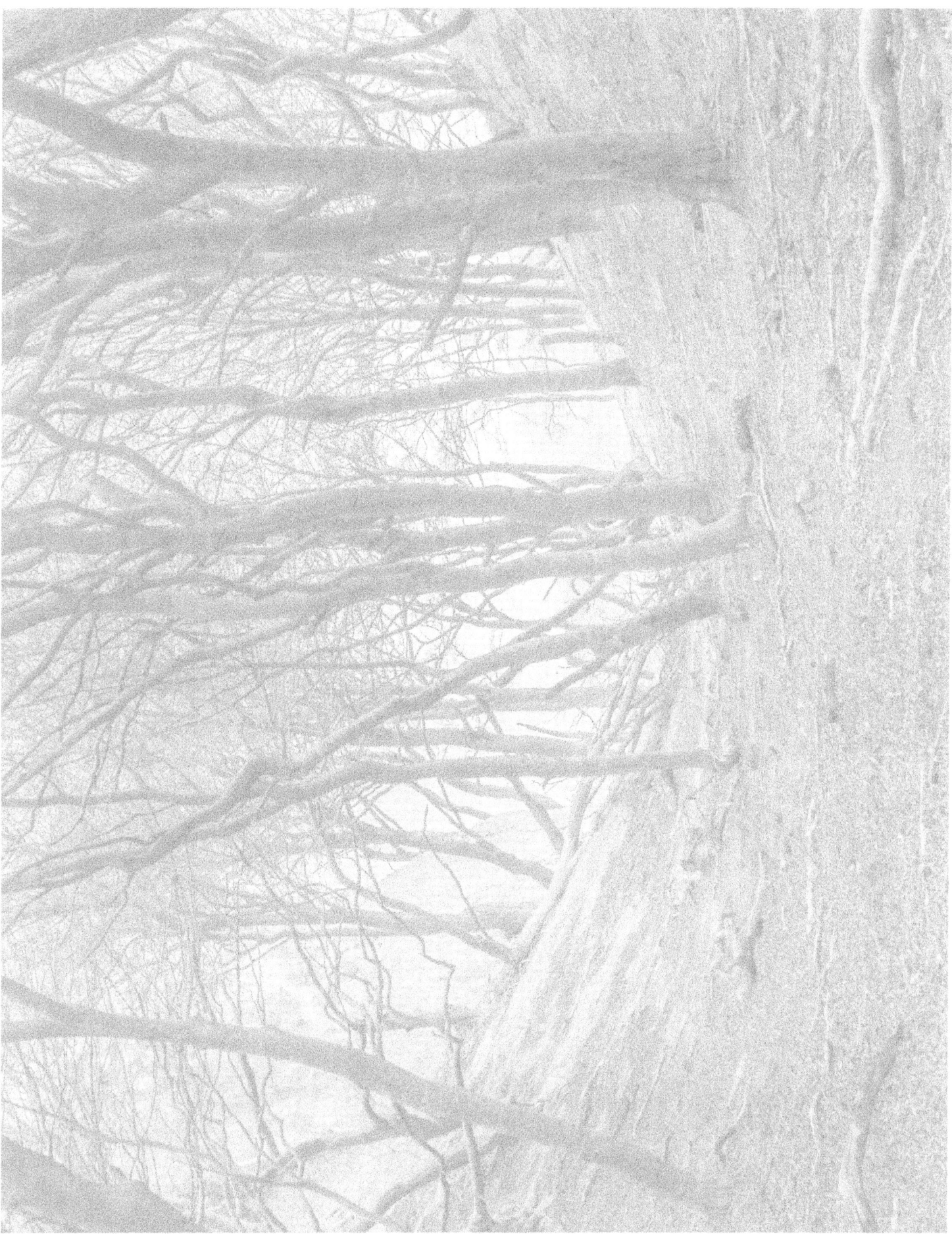

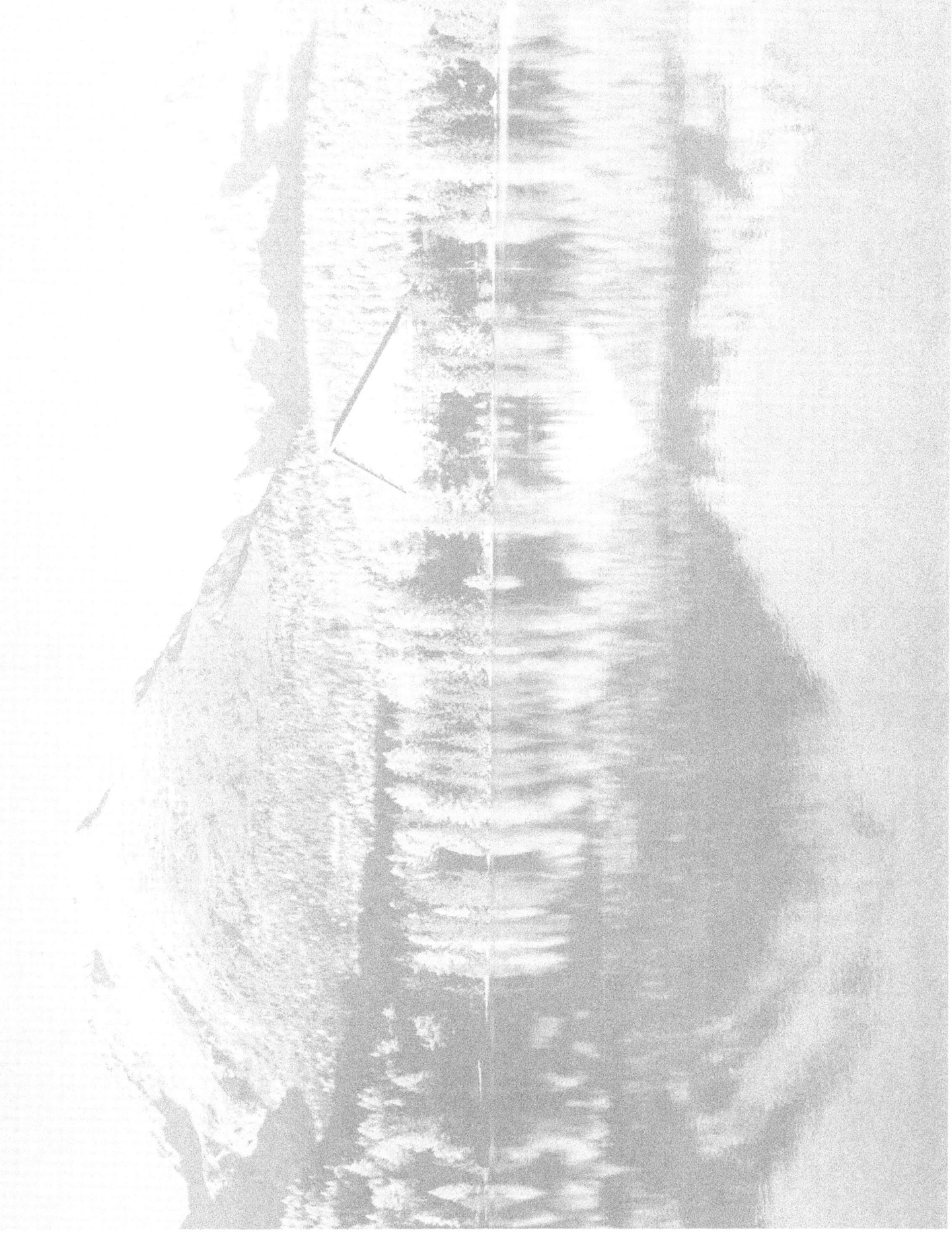

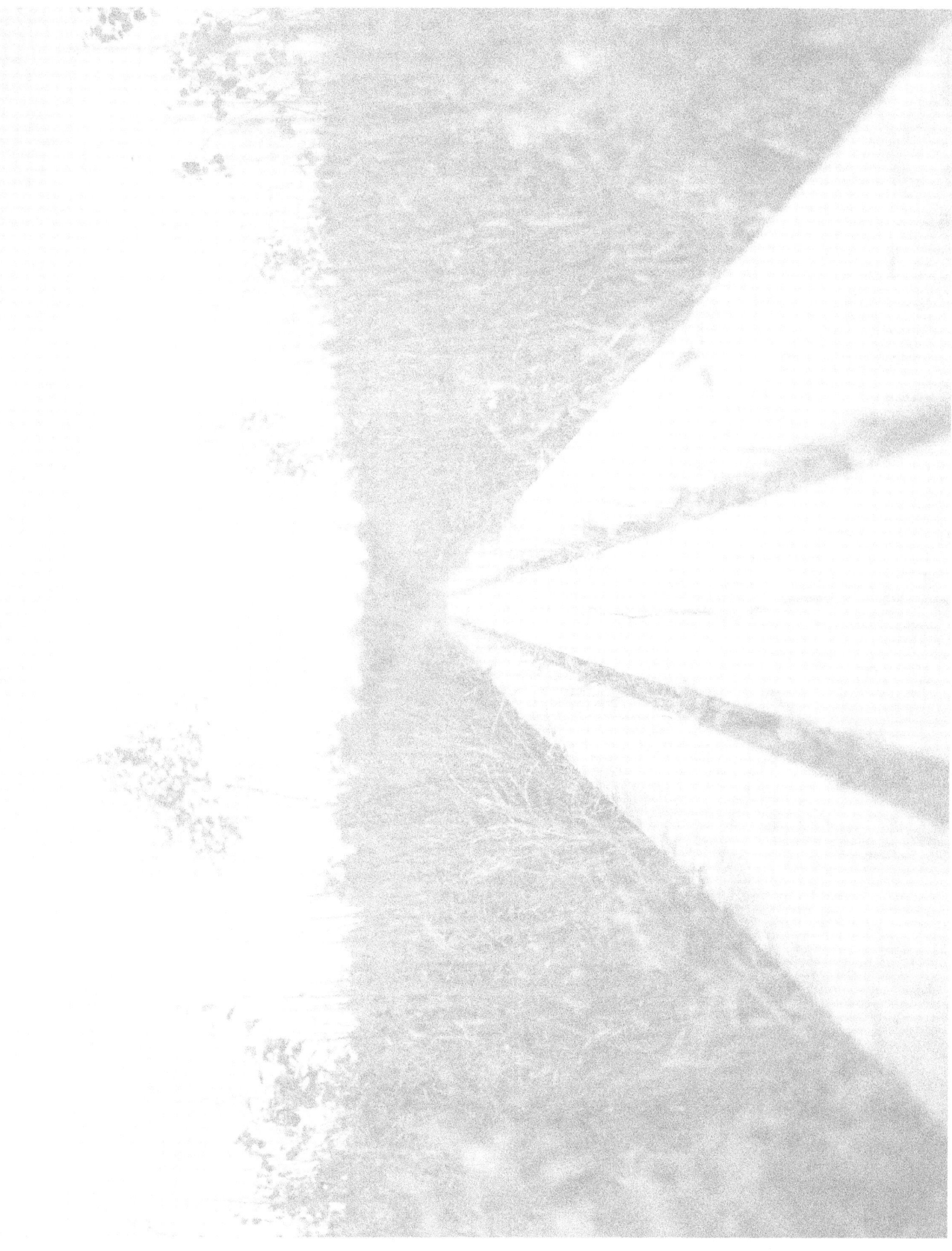

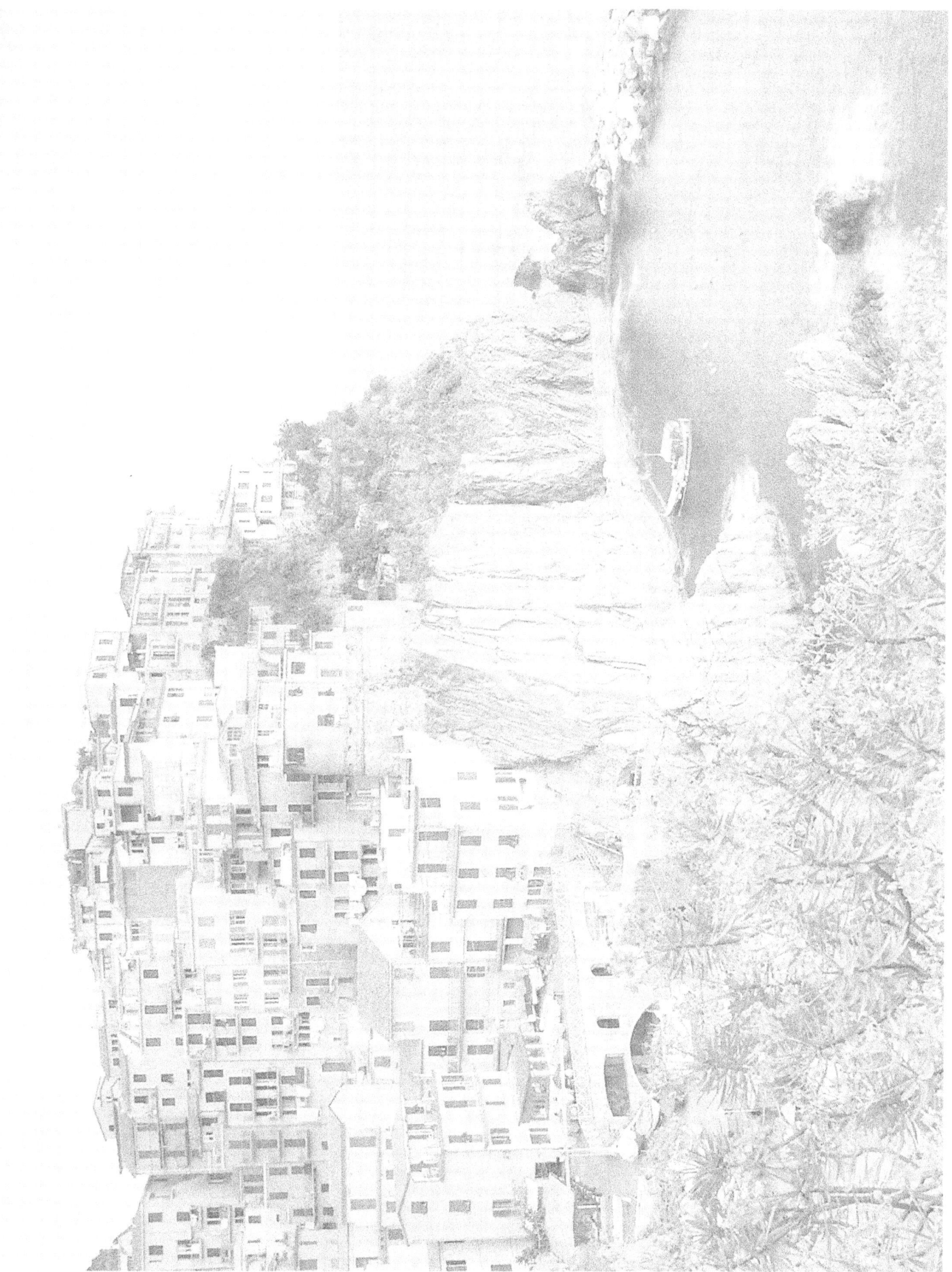

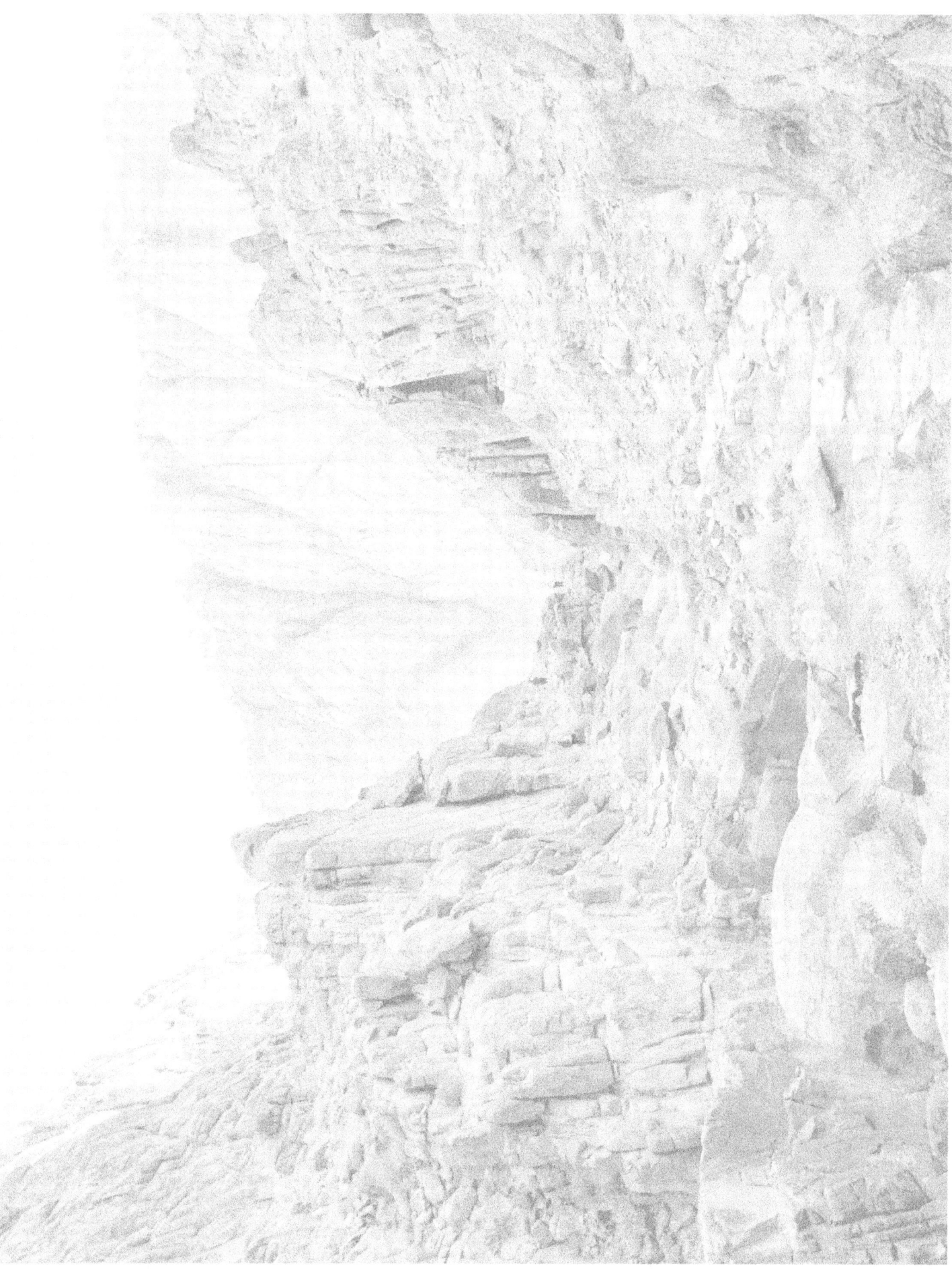

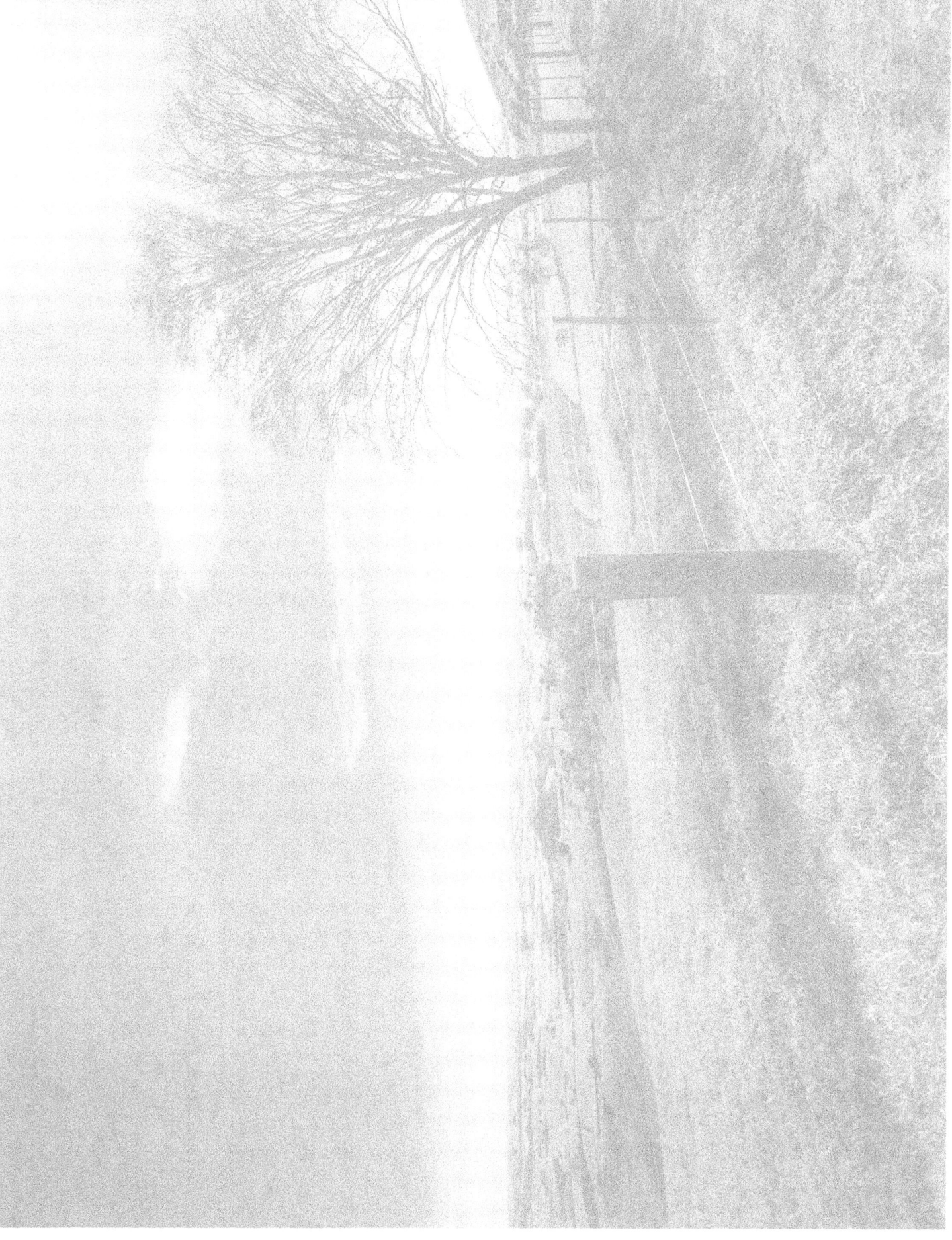

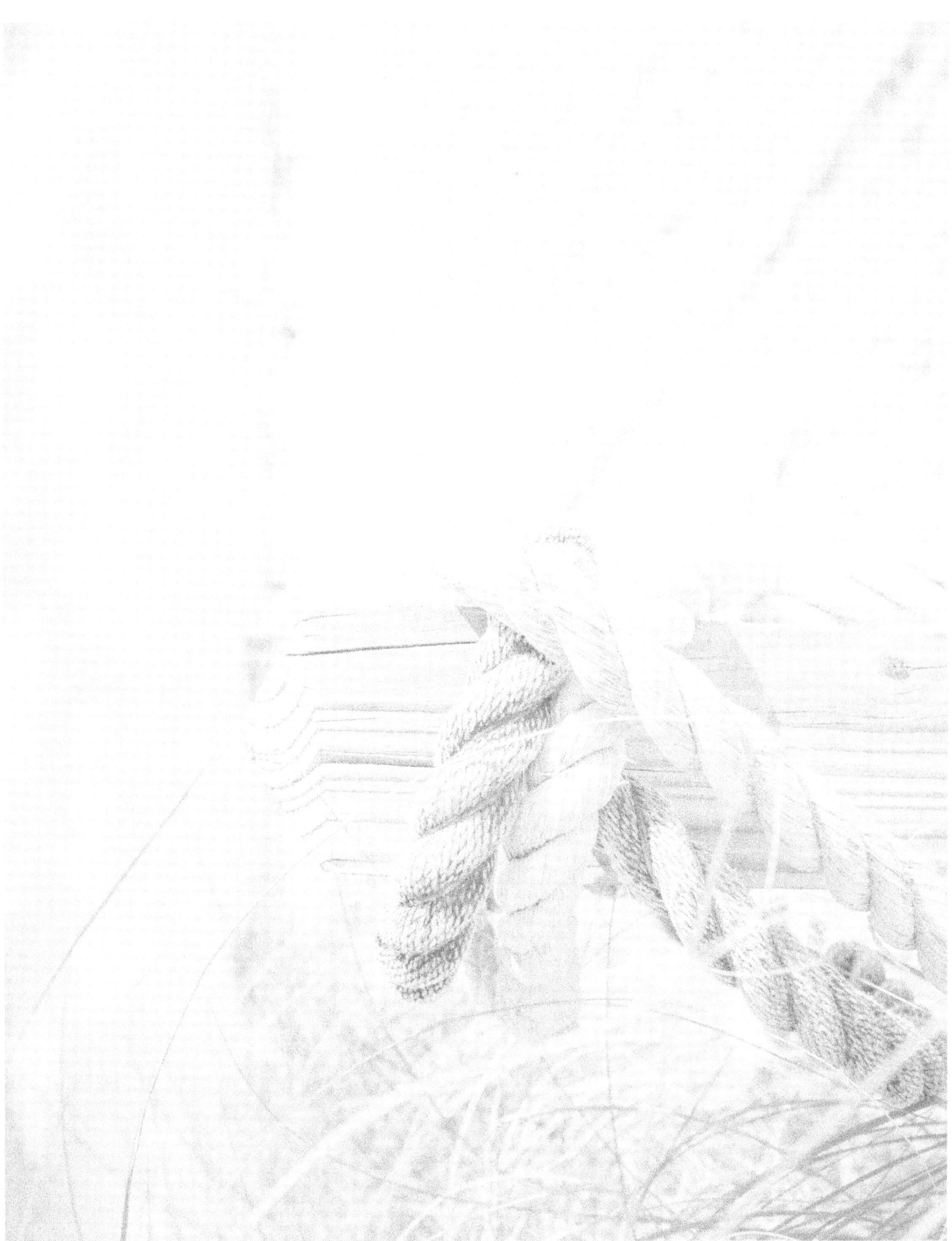

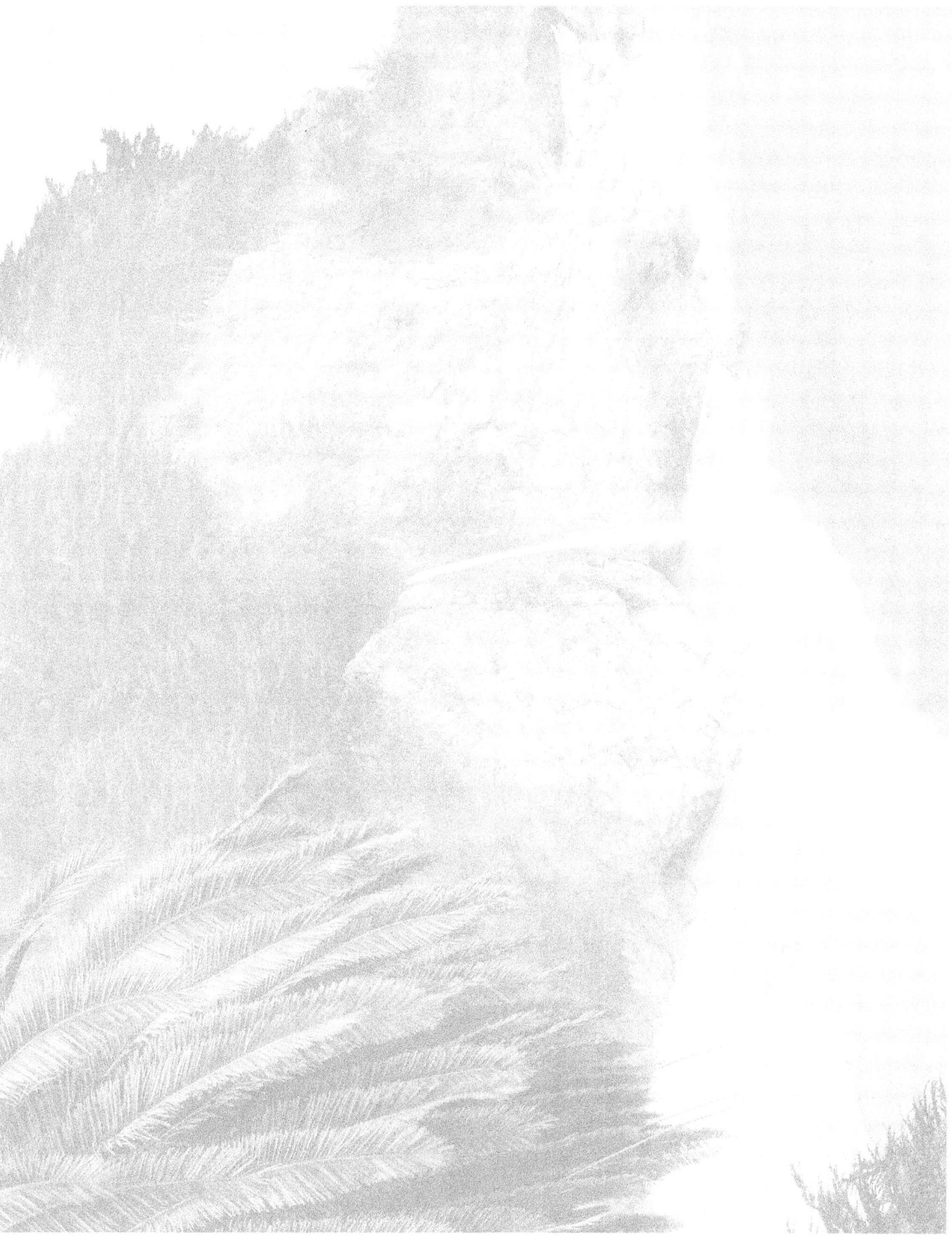

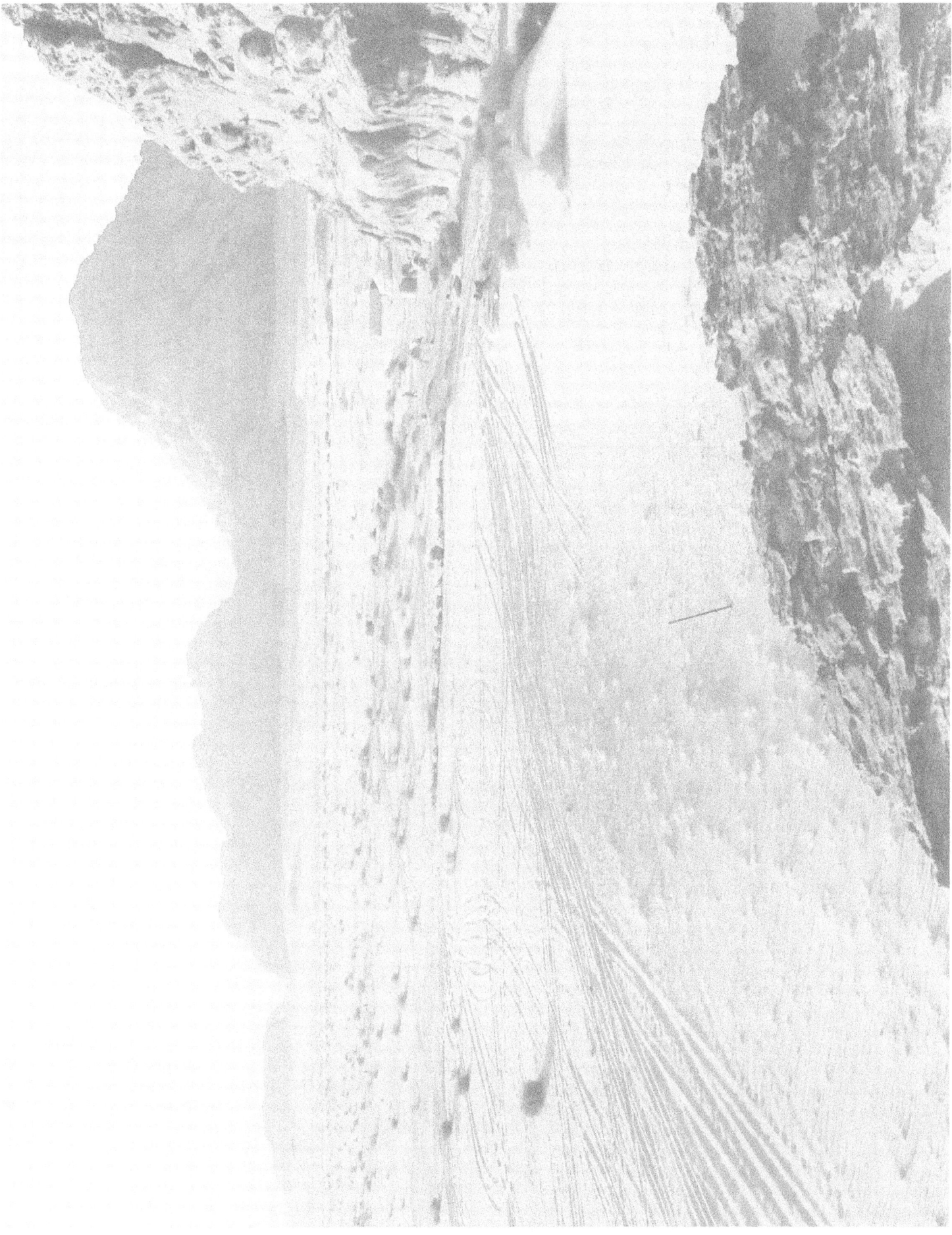

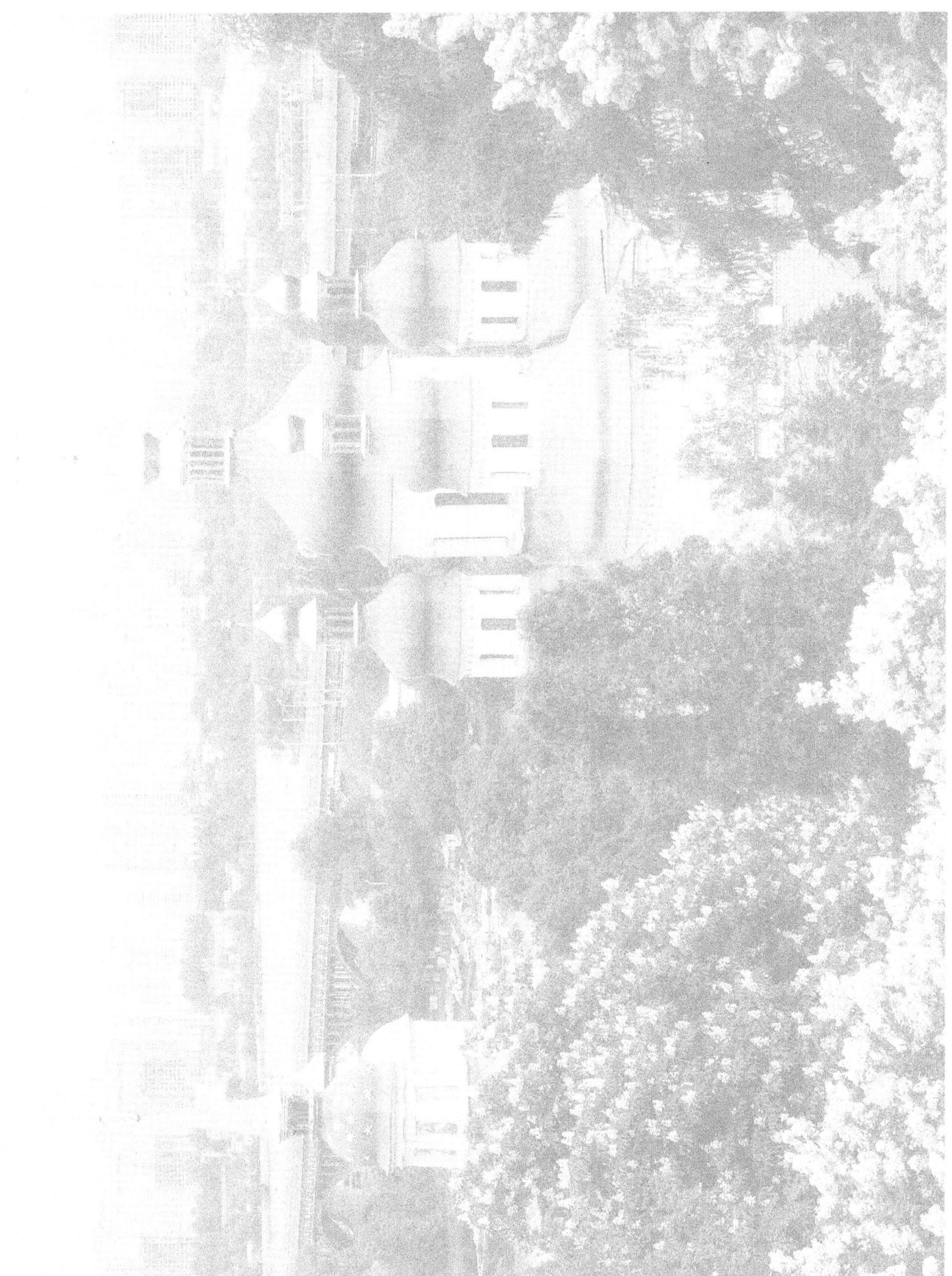

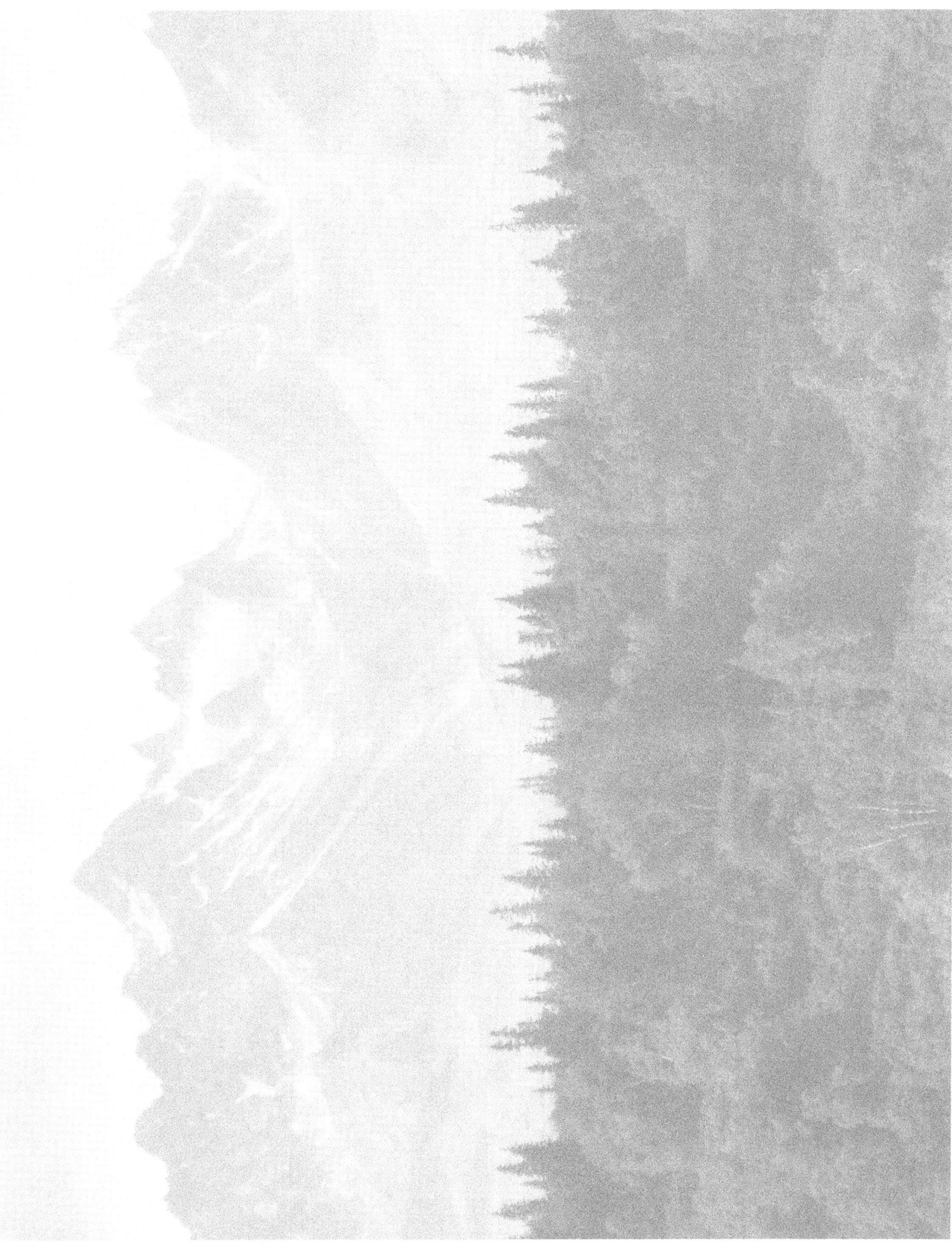